"To Set the Darkness Echoing"

AN EXHIBITION OF IRISH LITERATURE,

1950–2000

Personal Helicon

~~AN APPRENTICESHIP~~

As a child, they could not keep me from wells
And old pumps with buckets and windlasses.
I loved the dark drop, the trapped sky, the smells
Of waterweed, fungus and dank moss.

One, in a brickyard, with a rotted board top.
I savoured the soft crash when a bucket
Plummeted down at the end of a rope.
So deep you saw no reflection in it.

A shallow one under a dry-stone ditch
Fructified like any aquarium.
When you dragged out long roots from the thick mulch
A white face hovered over the bottom.

Others had echoes, gave back your own call
With a clean new music in it. And one
Was scaresome for there, out of ferns and tall
Foxgloves, a rat slapped across my reflection.

Always they scolded, beat me, said I'd drown.
I never obeyed, felt guilty all the time;
Forfeited much love for this love of my own,
Unwitting apprentice, even then, to rhyme.

SEAMUS HEANEY

[handwritten draft:]
Now, I rake, when I read how the ancients thought
That poets drank their poetry out from a well spring.
The metaphor The myth was apt: In water I had sought
To see myself the dark, myself my echo like a bell.
To see myself despite the darkness echoing.
to set

"To Set the Darkness Echoing"

AN EXHIBITION OF IRISH LITERATURE, 1950–2000

curated by

STEPHEN ENNISS

JAMES O'HALLORAN

RONALD SCHUCHARD

The Grolier Club

NEW YORK CITY · 2002

ON VIEW AT THE GROLIER CLUB

MAY 15 THROUGH JULY 27, 2002

ISBN 0-910672-43-1

Introduction

THIS EXHIBITION of Irish literature of the second half of the twentieth century was conceived and curated as a sequel to the Grolier Club's first exhibition of Irish literature, "The Indomitable Irishry," which was opened forty years ago by Professor William York Tindall and the Irish poet-playwright Padraic Colum. The title came from William Butler Yeats's imperative to Irish writers in one of his last poems, "Under Ben Bulben," to learn their trade and cast their minds on ancient days, "That we in coming days may be / Still the indomitable Irishry." Ranging from the publication of Yeats's first book, *Mosada* (1886), to works published by Irish authors in the decade after his death in 1939, the exhibition focused on rare and limited materials by writers of the Irish literary renaissance – Yeats, George Moore, George Russell (Æ), Lady Gregory, John Middleton Synge, James Joyce, Padraic Colum, Sean O'Casey, and others. Included with the many inscribed first editions were manuscripts, letters, broadsheets, theatre programs, periodicals, and publications by private presses, many from the collection of the exhibition curator, James Gilvarry, a member of the Grolier Club who had amassed one of the finest collections since John Quinn. To enhance the literary materials, Gilvarry brought in busts, oil portraits, pencil sketches, and photographs of the writers by such artists as John Butler Yeats, Augustus John, Edouard Manet, William Orpen, and William Rothenstein. Like that of the present curators, his aim was not to be comprehensive in his selection of authors and works but to bring briefly before the public eye, most for the first time, a variety of extraordinary

5

items that would soon be returned to the rarely glimpsed underworld of private and institutional collections. In showing the emergence of new writers from decade to decade, "The Indomitable Irishry" brought into view the early works of Samuel Beckett, Frank O'Connor, Patrick Kavanagh, and Louis MacNeice, all of whom reappear in the present exhibition as mature writers whose influence is strongly felt by Irish writers today.

The title of our new exhibition comes from the concluding lines of Seamus Heaney's "Personal Helicon," the manifesto poem of his first volume, *Death of a Naturalist* (1966): "I rhyme / To see myself, to set the darkness echoing." It is a poem in which the poet first declares his trust in tapping the unarticulated darkness in the well of the self, in the gift of a creative imagination that brings subterrene darkness into poetic light. In other early poems he celebrates the presence of a myriad of gift-holders in the Irish countryside – a water diviner whose forked hazel stick locates the "secret stations" of the earth, a thatcher whose artistry leaves his onlookers gaping at his "Midas touch," a blacksmith whose single entry into his fiery forge of art is likewise through "a door into the dark." And yet as Heaney affirms the power and purity of the imagination, he is always aware of the historical forces ready to threaten, restrain, oppress, or arrest its free operation in Ireland and in the world – censorship, sectarian politics, religious conflict, linguistic prejudice, civil violence. His poetry over the next thirty-five years demonstrates repeatedly the universal predicament of Irish writers in the twentieth-century, of remaining true to the imagination and the claims of art while being responsive or resistant to the times and the demands of history.

The historical conditions that bear upon the writers of the past fifty years continually remind us of those that affected their predecessors – of an archbishop's condemnation of Yeats's *The*

6

Countess Cathleen before the opening of the Irish Literary The-
atre, of the riots that greeted Synge's *The Playboy of the Western
World*, of Joyce's nine-year difficulty in finding a publisher for
Dubliners, and of the banning of *Ulysses* in America. After the
establishment of the Irish Free State, the Censorship Publica-
tions Act of 1929, which banned any reference to human sexuali-
ty and contraception, gave legal sanction to pious intervention
and seriously thwarted literary livelihoods and publishing in Ire-
land for half a century. Thus, J. P. Donleavy's hilariously rowdy
and racy novel about the sexual escapades of Sebastian Danger-
field, *The Ginger Man* (1955), was banned by the Board of Cen-
sors for twenty years, and an attempt to produce a stage version
in 1959 was foiled by clerical pressure. At the beginning of the
1960s, when Edna O'Brien published her *Country Girls* trilogy
about young women coming to maturity in a puritanical Ireland,
all three novels were banned. John McGahern's second novel
The Dark (1965) was not only banned; it cost him his teaching
job in a clerical school and necessitated his move to London,
where he had to work on a construction site. Such realities, in-
cluding the Troubles in the North, have led numerous Irish au-
thors to follow Joyce's example by taking their imaginative pos-
sessions into temporary or permanent exile: Samuel Beckett to
Paris; Brian Moore to Montreal; Louis MacNeice and Edna
O'Brien to London; Derek Mahon to London and New York.
Academic havens abroad have afforded other writers the needed
distance and financial support to continue their writing:
Thomas Kinsella at Southern Illinois and Temple; John Mon-
tague at SUNY Albany; Seamus Heaney at Berkeley and Har-
vard; Paul Muldoon at Princeton; Eavan Boland at Stanford;
Tom Paulin at Nottingham and Oxford. For every exile, howev-
er, there are writers like John Banville and Michael Longley who
have chosen to ride out the turmoils of Dublin and Belfast in

their homelands, though even Longley regularly retreats south and west to his beloved Carrigskeewaun in County Mayo, the isolated rural haven that has nourished and replenished his art from *Gorse Fires* (1991) to *The Weather in Japan* (2000).

The exhibition is arranged by decades from the 1950s, showing over the course of fifty years a selection of extraordinary books, manuscripts, letters, and other documents related to the production of imaginative literature in Ireland and the achievements of individual writers. Included are a series of bronze busts and art works that have been out of public view, including Louis le Brocquy's watercolor of Beckett, Barrie Cooke's oil of Heaney, and Basil Blackshaw's oil of Longley. Some writers appear in the windows of several decades when we are able to exhibit items from first publication through major volumes and awards, as in the instance of Heaney and Longley, or from mid-career to final publication, as in the instance of Beckett and MacNeice. In representing the development of Irish writing by decades, we have given special emphasis to the role of private presses in providing outlets for new voices.

The Dun Emer Press, later the Cuala Press, founded by Yeats's sisters in 1903 in hopes of reviving the art of printing in Ireland, had been an important outlet for Yeats, Æ, Synge, and others in the early years of the century. In the 1930s it brought Frank O'Connor into the light with his translations from the Irish, but the Press's last book appeared in 1946, creating a vacuum in private presswork until the architect Liam Miller founded the Dolmen Press, which was to become the finest literary press in Ireland until Miller's death in 1987. Thus, the exhibition begins appropriately with the modest first publication of the Dolmen Press in 1951, Sigerson Clifford's *Travelling Tinkers*. In the course of the decade, Dolmen would launch the first works and careers of Thomas Kinsella, John Montague, and Richard Murphy.

8

Murphy relied exclusively on the Dolmen Press until his work was taken up by T.S. Eliot's London firm, Faber and Faber, the publisher of Joyce's *Finnegans Wake* (1939) and MacNeice's *Autumn Sequel* (1954). In the next decade, under the leadership of the great editor Charles Monteith, Irish writers such as Brian Friel and Seamus Heaney would be added to Faber's expanding Irish list. Indeed, the story of Faber's invaluable contribution to Irish writing during the past fifty years has yet to be told.

After the publication of *The Great Hunger* (1942), one of the concluding works in "The Indomitable Irishry," Patrick Kavanagh began writing a series of verse satires on literary Dublin, sparing no one from his hostile criticism and moving toward the establishment of his short-lived *Kavanagh's Weekly* (April-July, 1952), in which he lashed out at the "provincial" writer ("no mind of his own . . . until he has heard what the metropolis . . . has to say on any subject") and expressed his influential idea of the "parochial" writer ("never in any doubt about the social and artistic validity of his parish"). Even as he wrote his thirteen-week diatribe, however, his view of the stagnation and mediocrity of post-revival writing and culture was being shattered by the prodigious publication in Paris, in French, of Samuel Beckett's great trilogy, *Molloy* (1951), *Malone Meurt* (1951), and *L'Innommable* (1953), punctuated by his even greater play, *En Attendant Godot* (1952), all soon translated into English by Beckett himself. Fast on the heels of Beckett's revolutionary works were *The Stories of Frank O'Connor* (1952), the first novels of Brian Moore, J. P. Donleavy and William Trevor, the first stories of Edna O'Brien, the first full-length collection of Kinsella's *Poems* (1956), Montague's *Forms of Exile* (1958), and the first offerings of a shy poet who published under the pseudonym "Incertus" (Seamus Heaney) in *Gorgon* (1959), a student publication of Queen's University, Belfast. As the fifties came to a close, the

remarkable resurgence of post-war Irish writing was well underway.

Beckett opened the sixties, in the prime of his career, with *Happy Days* (1961), the year that MacNeice published *Solstices*, his last volume of poems before his death in 1963. If the literary gossip of Dublin had somewhat subsided around O'Brien's *Country Girl* trilogy, it was all abuzz again with the success of Brian Friel's *Philadelphia, Here I Come* (1965), which played at the Dublin Theatre Festival before moving on to an extended run in London and later on Broadway. Meanwhile, a younger generation of poets had begun gathering in Belfast around Philip Hobsbaum, a lecturer at Queen's University, to form a writing workshop. The "Belfast Group," as it became known, a loosely-knit assemblage that included in its early years Heaney, Longley, and on at least one occasion Derek Mahon, provided an important forum for its members, who regularly exchanged and criticized their mimeographed poems, or "group sheets." The first pamphlet publications of these three emerging poets were occasioned by the Queen's Festival of Poetry at the University, which provided for the successive publication of Longley's *Ten Poems*, Heaney's *Eleven Poems*, and Mahon's *Twelve Poems* in the closing months of 1965. These modest University launchings were followed by their first major trade volumes, Heaney's *Death of a Naturalist* (Faber, 1966), Mahon's *Night-Crossing* (Oxford, 1968), and Longley's *No Continuing City* (Macmillan, 1969). In their midst appeared *New Territory* (1967), the first volume by Eavan Boland, a young poet whom Mahon and Longley had befriended at Trinity College, Dublin. These were the four poets who were coming into poetic maturity as the new siege of Troubles began, and they would all turn their heads back to Yeats, particularly to his "Meditations in Time of Civil War," for inspiration and guidance as their imaginations came face to face with a terrible violence.

By the end of the sixties Liam Miller's Dolmen Press had achieved international recognition and prominence not only for its impressive list of Irish poets and playwrights but for its beautifully designed and illustrated books. Surely the crown jewel of the press was set in place with the publication of the Irish epic tale, *The Táin* (1969), acclaimed for the translation by Thomas Kinsella, the vigorous brush drawings by Louis le Brocquy, and the general design by Miller, truly a masterpiece of artistic collaboration. Even as the Dolmen Press reached maturity under Miller, however, a young aspiring poet-publisher at Trinity College, Dublin, Peter Fallon, had organized a writer's workshop that called itself the Tara Telephone Poetry Workshop. Setting up his press in 1970, Fallon printed eight books under the Tara Telephone imprint before changing the name to the Gallery Press, aiming from the beginning to help launch and foster the careers of exceptional new writers and provide them with a publishing home in Ireland. When the torch was finally passed from Miller to Fallon, the Gallery Press became the leading literary publisher in Ireland. Now in its thirty-second year, it has published over three hundred books of poems, plays and prose by most of Ireland's leading writers – Montague, Friel, Heaney, Mahon, Banville, Paul Muldoon, Medbh McGuckian, Ciaran Carson, Eiléan Ní Chuilleanáin, Nuala Ní Dhomhnaill, and many others. The increasing cooperation of the Dolmen and Gallery presses with the Wake Forest University Press in North America from 1976 has made possible the widespread teaching here of contemporary Irish literature, one of the fastest growing scholarly fields in American universities.

The last year of the sixties saw not only the sumptuous edition of *The Táin* at Dolmen but also Heaney's second volume at Faber, *Door Into the Dark*, in which he began to explore in "Bogland" the metaphor that would reach its full symbolic import in

North (1975). But Heaney had also taken up the role of finding new poetic talents and introducing them to Irish readers, witnessed by his including in *Threshold* (1969), a little magazine for which he was guest editor, the first published poems of Paul Muldoon, then still a schoolboy (sixth-former) in Armagh. Muldoon subsequently became one of Heaney's students at Queens, as did Medbh McGuckian, whose marked essay for Heaney on "The Idea of an Anglo-Irish Poetic Tradition" is included here. Muldoon's first pamphlet of poems, the rare *Knowing My Place* (1971), appeared while he was still an undergraduate. Muldoon and McGuckian, many readers believe, have gone on to become two of the most inventive and metaphoric poets writing today. The extension of the British Education Act to Northern Ireland in 1947 had begun to pay dividends with new writers and readers, as would the introduction of free second-level education in the Republic of Ireland in 1968.

With the publication of *Acts and Monuments* in 1972, Eiléan Ní Chuilleanáin became one of the young, first-volume authors of the Gallery Press, which continues to publish her work today. Muldoon, on the other hand, was picked up by Faber and Faber, which published his first two trade volumes, *New Weather* (1973) and *Mules* (1977). As these and other young writers appeared on the seventies scene, and as the violence mounted in the North, Kinsella and Montague came into full force with two striking long poems, *Butcher's Dozen* (1972) and *The Rough Field* (1972). *Butcher's Dozen*, issued a week after the Widgery Tribunal's exoneration of the British Paratroop Regiment for the shooting of thirteen civil rights demonstrators in Derry on Bloody Sunday (30 January 1972), responded movingly to the carnage and outrage. Kinsella, who had become a director of the Dolmen Press and of the Cuala Press upon its revival in 1969, published the poem as the inaugural volume of his own Dolmen-inspired

Peppercanister Press, still active today and known for its special boxed editions with handmade paper and full leather bindings. Meanwhile, Dolmen was bringing out *The Rough Field*, Montague's epic, nationalist portrayal of the accelerated deterioration of Ulster life since the war. The ten-section volume contains his famous lyric poem, "Like dolmens round my childhood," which is often published separately in anthologies. Lavishly illustrated with woodcuts depicting Irish life from John Derricke's *A Discoverie of Woodkarne* (1581), *The Rough Field* was printed with marginalia comprised of historical documents, tracts, and letters from the time of Hugh O'Neill during the reign of Elizabeth I to the present Northern conflict under the reign of Elizabeth II. Shortly after the volume appeared, Liam Miller adapted the poem for a collaborative presentation at Dublin's Peacock Theatre, with music by the Chieftains and readers who included Montague, Benedict Kiely, Alun Owen, and Tom McGurk. The following year a performance of this reading was held in London by the British Irish Association, with Seamus Heaney and Patrick Magee added as readers of Montague's major achievement.

The seventies also saw Jennifer Johnston burst upon the scene with a succession of novels from *The Captains and the Kings* (1972) to *The Old Jest* (1979) that explore a pervasive theme in Anglo-Irish writing since the eighteenth century, the "Big House," referring to the big houses of the ascendancy and the gradual decline of the Protestant landowning class, a topic of continuing fascination in Ireland. Johnston's novels show how the class barriers between the big house and Catholic Ireland intensify the isolation of individual characters, but the violence in the North diverted her from these interests in her fourth novel, *Shadows On Our Skin* (1977), where in working-class Derry she dramatizes the tragic relationship between a Catholic schoolboy and his Protestant teacher in the hostile environment of the IRA and the British soldiery.

The eighties were given a special launch when Brian Friel and the actor Stephen Rea founded in the border city of Derry the theatrical company, Field Day, with hopes of revitalizing dramatic activity in the city and setting in motion a cultural movement to redefine cultural identity in Ireland, North and South, Catholic and Protestant. Its first production, which set the tone of Field Day, was Friel's *Translations* (1980), perhaps the most provocative and acclaimed play of the past twenty years. Friel and Rea were soon joined on the board by Heaney, Seamus Deane, Tom Paulin, and the folklorist David Hammond, and they forwarded the cultural debate with the establishment of a pamphlet series in 1983, inaugurated with Paulin's *A New Look at the Language Question*, Heaney's *An Open Letter*, and Deane's *Civilians and Barbarians*. Over the decade the company produced new plays and translations of Greek and French plays by its own members and by Mahon (*High Time*, his 1985 translation of Molière's *School for Husbands*), Tom Kilroy (*Doublecross*, 1986), Stewart Parker (*Pentecost*, 1987), and Terry Eagleton (*St. Oscar*, 1989). By mid-decade Seamus Deane had begun to edit the board's major initiative, the three-volume *Field Day Anthology of Irish Writing* (1991), but even before it appeared Eavan Boland had begun to address in her pamphlet, *A Kind of Scar* (1989), and later in *Object Lessons* (1995), what would be recognized as the anthology's major weakness, the under-representation of women writers in the Irish tradition, a weakness that is being addressed in a forthcoming fourth volume.

As the eighties progressed, a young generation of writers began to find their full poetic power: Paulin in *Fivemiletown* (1987), Muldoon in *Meeting the British* (1987), McGuckian in *On Ballycastle Beach* (1988), Carson in *The Irish for No* (1987), and *Belfast Confetti* (1989), which won the Whitbread Poetry Award and the *Irish Times* / Aer Lingus Prize for Poetry. Members of

14

an older generation were still writing vibrantly, particularly the novelist Benedict Kiely, who continued to inveigh against the violence of Catholic and Protestant extremists alike, both in *Proxopera* (1977) and *Nothing Happens in Carmincross* (1985). Before the decade ended, Samuel Beckett, who had received the Nobel Prize in 1969 for his massive achievement as novelist, dramatist, and poet, was to publish his final work, a volume of verse, *Stirrings Still* (1988).

The nineties brought both a full flowering for one generation and a new flourishing for younger talents in all genres, such that a major exhibition might be held on this decade alone, ushered in as it was by Friel's magnificent *Dancing at Lughnasa* (1990). Boland's *In a Time of Violence* (1994) was followed by a Lannan Award for Poetry; Muldoon's *The Annals of Chile* (1994), which contains his moving elegies "Incantata" and "Yarrow," received the first T. S. Eliot Poetry Prize, Carson's *First Language* (1994) the second; Heaney's *The Spirit Level* (1995) was followed by the Nobel Prize, Longley's *The Weather in Japan* (2000) by the Queen's Gold Medal for Poetry. Mahon's *The Hudson Letter* (1995) and *The Yellow Book* (1997), volumes of dynamic poetic renewal, were followed by his long-waited *Collected Poems* (1999).

Two autobiographical novels, Seamus Deane's *Reading in the Dark* (1996), shortlisted for the Booker Prize, and Frank Mc-Court's Pulitzer Prize-winning *Angela's Ashes* (1996) continued to reveal the haunting and disabling nature of violence and poverty on Irish sensibilities. And yet the nineties novels of Roddy Doyle, Patrick McCabe, and Colm Toibín, and the plays of Sebastian Barry show how rapidly the landscape of Irish fiction and drama is changing and what a tremendous readership for Irish books, literary and popular, now exists in Ireland. And this holds true for the expanding number of readers of Irish as well, thanks to the enormous and committed talents of Breandán

Ó hEithir, whose *Lig Sinn I gCathú* (1976) enjoyed an astounding success as the first best-seller in Irish, beating all English language comers in Ireland; Nuala Ní Dhomhnail, whose *Pharaoh's Daughter* (1990) was translated by a baker's dozen of her fellow English language poets; Michael Hartnett, the dual language poet whose writings in Irish opened up new metrical sources for him, and the younger Cathal Ó Searcaigh, whose poems in *An Bealach 'na Bhaile* (1991) have been translated by Heaney and others. As the century came to a close, it was also clear that the place of women's writing in Ireland had been strongly established by a wide range of extraordinary volumes and awards by Rita Ann Higgins, Mary O'Malley, Vona Groarke, Sara Berkeley, Kerry Hardie, Caitríona O'Reilly, the Irish language poet Biddy Jenkinson, and others. It has been a great fifty years for Irish writing, and in presenting this limited exhibition of its many riches the curators, who are indebted to our predecessors and fellow collectors for their example and encouragement, trust that this exhibition will be only the second in a continuing tradition of regular Grolier gatherings of Irish literature.

Ronald Schuchard

EMORY UNIVERSITY, ATLANTA, GEORGIA

Catalogue of the Exhibition

First publication of the Dolmen Press

Travelling Tinkers, by Sigerson Clifford, title page

design by Liam Miller, Dublin: Dolmen Press, 13 August 1951. No. 80
of 100 signed copies in cloth (out of a total edition of 500).

Collection of James O'Halloran

The contributions to Irish literature of Liam Miller and his
Dolmen Press can hardly be overstated. At the time Miller
founded his small hand press, Irish authors had virtually no
publisher for their work in their native country. As Thomas
Kinsella has noted, Miller established Dolmen primarily in
order to indulge an interest in fine printing and design.
"Many of the Press's early publications," he writes, "were
hand-set experimental pamphlets where the literary content
mattered little. But from the beginning the Press set itself
the object of publishing work by Irish authors and soon
found itself dealing with a new Irish poetry." On the twenty-
fifth anniversary of the Press, Miller recalled that the origi-
nal impulse had been "to do something simple and honest
and four-square and straight which our first book, may I say,
wasn't at all."

Molloy, by Samuel Beckett, Paris: Les Amis des Éditions de Minuit, 1951. No. 164 of 500 copies.

Robert W. Woodruff Library, Emory

Malone Meurt, by Samuel Beckett, Paris: Éditions de Minuit, 1951.

Robert W. Woodruff Library, Emory

L'Innommable, by Samuel Beckett, Paris: Éditions de Minuit, 1953.

Robert W. Woodruff Library, Emory

At the time that he published *Molloy*, *Malone Meurt*, and *L'Innommable*, Samuel Beckett had been living abroad for many years. His decision to switch from writing in English to writing in French in the late 1940s deepened his own expatriation and led to a remarkable period of productivity (*En Attendant Godot* was completed and first performed during this same period). His motive, as he explained it, had been simply "pour faire remarquer moi." Beckett had great difficulty finding a publisher for this trilogy, largely due to the poor sales of *Murphy*, which had been published in Paris by Pierre Bordas in 1947. The novels were finally accepted by a new young French publisher Jérôme Lindon who issued them under the Éditions de Minuit imprint. Early acclaim for *Molloy* and *Malone Meurt* prompted Bordas to reconsider his earlier rejection of the novels, and the ensuing legal dispute delayed the publication of *L'Innommable* until 1953.

Kavanagh's Weekly, edited by Patrick Kavanagh, Vol. 1,
No. 13, July 5, 1952. No. 31 of 200 signed copies.

Robert W. Woodruff Library, Emory

Patrick Kavanagh Portrait head by Desmond
MacNamara, bronze resin, ca. January 1961

Robert W. Woodruff Library, Emory

Patrick Kavanagh and his brother, Peter, founded *Kavanagh's
Weekly* in 1952 as a vehicle for their own social, political, and cul-
tural commentary. Patrick contributed much of the copy includ-
ing the opening number's editorial attack on Irish mediocrity.
Even though he was highly critical of Ireland, he also affirmed it
as his own. "It is only by starting from this barren – but our own –
ground that we can achieve anything," he wrote in the opening
number. The newspaper ran for a mere three months, at which
point the brothers' savings were depleted and the *Weekly* ceased
publication.

In January 1961 the artist Desmond MacNamara completed a
sketch of Patrick Kavanagh from which this bronze portrait head
was later modeled. MacNamara persuaded Kavanagh to sit for the
sketch by inviting him to his studio to watch horse racing on
MacNamara's television. According to Kavanagh's biographer,
MacNamara's son was recruited as a runner to go out periodically
and place bets on the races. Kavanagh is not believed to have sat
for any other sculptor.

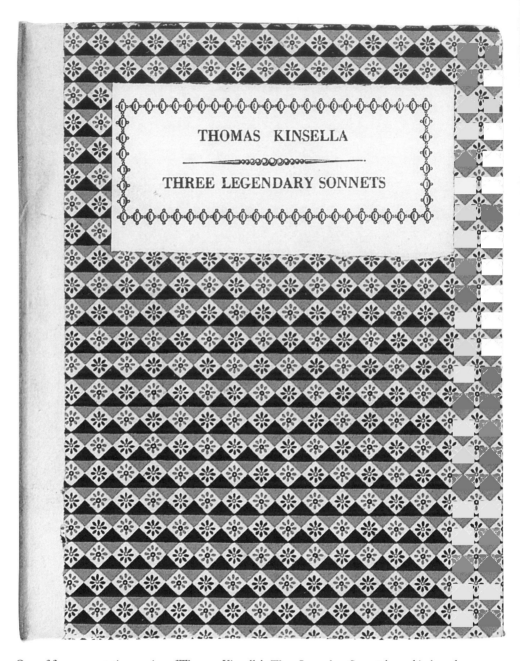

One of five presentation copies of Thomas Kinsella's *Three Legendary Sonnets* bound in boards.

The Starlit Eye, by Thomas Kinsella, with drawings by

Liam Miller, Dublin: Dolmen Press, March 1952. Printed in an edition of 175 copies.

Robert W. Woodruff Library, Emory

Three Legendary Sonnets, by Thomas Kinsella,

Dublin: Dolmen Press, December 1952. No. 4 of 5 presentation copies bound in boards (out of a total edition of 100).

Robert W. Woodruff Library, Emory

Thomas Kinsella's first book, *The Starlit Eye*, was published while Kinsella was working in the Irish civil service and was only the fourth title issued by Liam Miller's Dolmen Press. The chapbook was printed by hand in an edition of 175 copies. Miller was new to press work and his early publications were collective endeavors with authors often helping to set type for their own books, as Kinsella did for his second Dolmen publication, *Three Legendary Sonnets*, issued later that same year. The copy displayed here is one of only five bound in boards for presentation.

The Stories of Frank O'Connor, by Frank

O'Connor, New York: Knopf, 1952.

Robert W. Woodruff Library, Emory

Michael Francis O'Donovan combined his own middle name with his mother's maiden name to derive the pen name Frank O'Connor. Over the course of his career, his short stories enjoyed great popularity in the U.S. where he was also able to escape the censorship that had at times plagued him in Ireland. By the 1940s his U.S. reputation was such that the *New Yorker* secured a first option on any new work, and in August 1952 Alfred Knopf issued his collected stories to critical acclaim.

Autumn Sequel, by Louis MacNeice, London: Faber and Faber, 1954.

Robert W. Woodruff Library, Emory

Canto XVIII, by Louis MacNeice, signed holograph manuscript, ca. February 1954.

Harry Ransom Humanities Research Center, Texas

Louis MacNeice, Faber and Faber publicity photograph, n.d.

Robert W. Woodruff Library, Emory

Louis MacNeice's verse tribute to the Welsh poet Dylan Thomas was originally published as a work in progress in the *London Magazine* in February 1954, shortly after Thomas's death at the age of thirty-seven. The poem – part of a larger sequence – was broadcast by the BBC in the summer of 1954 before being collected as Canto XVIII in MacNeice's *Autumn Sequel*.

The Archaeology of Love, by Richard Murphy, Dublin: Dolmen Press, October 1955, in an edition of 200 copies.

Collection of James O'Halloran

"Sailing to an Island," by Richard Murphy, Dublin: Dolmen Press, 1955. No. 19 of 35 copies.

Loan of an anonymous collector

Richard Murphy's *Archaeology of Love* was issued by Liam Miller's Dolmen Press in 1955. The collection subsequently received the Æ Memorial Award. The accompanying chapbook, *Sailing to An Island*, was originally intended for publication in *The Archaeology of Love* but was instead issued separately in a small limited edition of 35 copies.

The Ginger Man, by J. P. Donleavy, typescript with
extensive autograph revisions by Donleavy and Brendan Behan, n.d.

Loan of J. P. Donleavy

J.P. Donleavy at his writing desk, photograph,
Kilcoole, Co. Wicklow, [ca. 1951]

Loan of J. P. Donleavy

The Ginger Man, by J. P. Donleavy, Paris: Olympia Press
(Traveller's Companion series ; no. 7), 1955.

Robert W. Woodruff Library, Emory

J. P. Donleavy dropped out of Trinity College, Dublin, and moved
to a cottage near Kilcoole, Co. Wicklow, where he began writing
The Ginger Man in 1951. The playwright Brendan Behan read and
made suggestions on this early typescript and later predicted that
the novel would "reverberate around the world." However, the
novel was rejected by numerous publishers before Donleavy sent it
to Maurice Girodias of the Olympia Press whose Traveller's
Companion series was known for its pornographic content. Now
considered an underground classic, the novel was banned in
Ireland for twenty years.

"I was told they would pay in advance,"
Brian Moore's first novel, *Wreath for a Redhead*, Harlequin, 1951.

Robert W. Woodruff Library, Emory

Judith Hearne, by Brian Moore, London: Andre Deutsch,
1955.

Robert W. Woodruff Library, Emory

Brian Moore wrote his first novel, *Wreath for a Redhead*, in 1950
soon after emigrating to Canada. The novel was issued the fol-

lowing year by Harlequin, a Canadian publisher of popular thrillers and romance fiction. Over the next few years Moore would publish five more formula novels before publishing what he would describe as his first "real" novel, *Judith Hearne*, in 1955. In later years, Moore explained that he took on such work only after quitting his job as a proofreader with the Montreal *Gazette* and deciding to live by his writing. "I was told they would pay in advance," he explained, "and I thought that way I could go on writing *Judith Hearne*."

"A Friend of the Family," by Brian Moore, typescript with corrections in Moore's hand, [ca. 1951]

University of Calgary Library

"Miss Hearne," autograph note, timeline of Judith Hearne's life, n.d.

University of Calgary Library

"The characters," typescript notes identifying models for *Judith Hearne*, n.d.

University of Calgary Library

Brian Moore's short story "A Friend of the Family" tells of an elderly woman, Mary Judith Keogh, who used to visit the Moore family. When he decided to expand her story into a novel about the loss of faith, Moore said, "I remembered Miss Keogh . . . and I remembered that little story about her. I could hear her voice, I could envisage where she lived." The accompanying notes, in Moore's hand, provide a timeline of Miss Hearne's life and identify other models for the novel's fictional characters. *Judith Hearne* was first published in London by Andre Deutsch in May 1955.

24

Poems, by Thomas Kinsella, Dublin: Dolmen Press, 1956.

Robert W. Woodruff Library, Emory

"A Shout After Hard Work," typescript, n.d.

Robert W. Woodruff Library, Emory

The Dolmen Press issued Thomas Kinsella's first full-length collection of poems in 1956, a year after Kinsella's marriage to Eleanor Walsh, to whom the volume is dedicated. Its publication marked an important milestone for the poet, who has stated simply, "It was in a few of these poems that I became sure." All known copies of the book have had the final poem razored out and its title pasted over on the table of contents page. The single poem excised from the published volume, "A Shout after Hard Work," appears here in a single surviving typescript from the Thomas Kinsella papers at Emory.

A Standard of Behavior, by William Trevor, London: Hutchinson, 1958.

Collection of James O'Halloran

William Trevor with Jane Donaldson, Assia Wevill, and Sean Gallagher in a Notley Advertising Agency publicity photograph, Summer 1960.

Robert W. Woodruff Library, Emory

William Trevor published his first novel, *A Standard of Behaviour*, in 1958, though he was later dismissive of this early effort and dropped it from lists of his own publications. In the early 1960s, Trevor worked as a copywriter for the Notley Advertising Agency where, as he has written, he "watched the birth of point-of-sale material for VP Wine, Kenco coffee, Wolsey underwear, and Britvic fruit and tomato juices." In this photograph taken at the

time, Trevor (at the typewriter with a champagne glass) poses for a publicity shot with his colleagues, including Assia Wevill (who would become the partner of poet Ted Hughes). In the early 1960s Trevor contributed stories to such publications as the *Transatlantic Review* and the *London Magazine*. He expanded one early story from this period into the novel *The Old Boys,* which subsequently won the Hawthornden Prize.

"One of the first stories I ever wrote"

"Jansen," by Edna O'Brien, typescript with holograph corrections, n.d.

Robert W. Woodruff Library, Emory

"Mummys Don't Cry," by Edna O'Brien, typescript with revisions in Edna O'Brien's hand and with an unidentified editor's notes, ca. 1958.

Robert W. Woodruff Library, Emory

Edna O'Brien wrote a number of previously unknown short stories under the pseudonym Dina Bryan, and in the late 1950s she sought to place her early stories in the popular women's magazines of the day. In his notes accompanying this typescript of "Mummys Don't Cry," an unidentified editor (possibly Peadar O'Donnell of *The Bell*) makes clear the kinds of constraints O'Brien would later contend with throughout her early career. He writes,

"Your readers will feel that [the protagonist's] behaviour does not do credit to a married woman with young children and an obviously nice and decent husband. At no time does the story suggest that Margaret is in love with this Italian. So far as I can judge she is merely attracted to the sex he emanates. If you are seeking to satisfy the requirements of the various woman's magazine editors, this slant will not do. . . . any hint of promiscuity, or some mysteri-

26

ous desire that is not love, is something which the normal woman does not understand and does not wish to read about."

With a corrected typescript of the short story "Jansen," which, according to the note in O'Brien's hand, was "one of the first stories I ever wrote."

Forms of Exile, by John Montague, Dublin: Dolmen Press, 1958. No. 26 of 50 numbered and signed copies.

Robert W. Woodruff Library, Emory

John Montague, Liam Miller, and Thomas Kinsella, photograph, n.d.

Loan of John Montague

As John Montague has noted, the founding of the Dolmen Press coincided with "the diffident first steps" of poets Richard Murphy, Thomas Kinsella, and himself. Montague who had recently returned to Ireland after a period of teaching in the U.S., first met Liam Miller in Dublin in 1956. The poet and publisher soon came to be close friends. When Miller was forced to delay the publication of Montague's first collection, *Forms of Exile*, Montague realized just how constrained the Press's finances were. Montague recalls paying £40 in order to facilitate publication.

The Woman of the House, by Richard Murphy, Dublin: Dolmen Press, May 1959. No. 2 of 25 signed on handmade paper, out of a total edition of 225 copies.

Collection of James O'Halloran

Richard Murphy's long poem *The Woman of the House* was broadcast on the BBC in 1959 and issued in a limited edition by the Dolmen Press that same year. The poem is a verse tribute to the

poet's grandmother, one that acknowledges the deep responsibilities of family heritage:

> "Through our inheritance all things have come,
> The form, the means, all by our family"

As Liam Miller recalls, its publication prompted an extended debate in the pages of the *London Magazine* and the *Times Literary Supplement* over the nature of the poet's craft.

Gorgon: A publication of the English Society, Queen's University, Belfast, Nos. 3 & 4, 1959–1960.

Loan of Seamus Heaney

While a student at Queen's University, Belfast, Seamus Heaney first began publishing under the pseudonym Incertus. As he recalled years later in *Stations*:

> "I went disguised in it, pronouncing it with a soft church-Latin c, tagging it under my efforts like a damp fuse. Uncertain. A shy soul fretting and all that. Expert obeisance.
> Oh yes, I crept before I walked. The old pseudonym lies there like a mouldering tegument."

The November 1959 *Gorgon* includes the uncollected poem "Nostalgia in the Afternoon," Heaney's second appearance in print, while the February 1960 number contains, under the name Seamus J. Heaney, the poem "Aran." Heaney used this form of his name through 1962, before settling in 1963 on plain Seamus Heaney.

1959

Seamus Heaney. *Seamus Heaney*

GORGON

A Publication of the English Society
Number 3. Q.U.B. Nov. 1959

EDITED
BY

DONATUS. I. NWOGA.

CONTENTS:

Poems by
George McWhitter, Elizabeth Miller, Alma
Graham, David Farrell, Stewart
Parker, Alan Gabbey, John Ritchie.

" .and Nature breeds,
Perverse, all monstrous, all prodigious things,
Abominable, inutterable, and worse
Than fables yet havefeigned or fear conceived,
Gorgons, . . .

The November 1959 *Gorgon* includes Seamus Heaney's poem "Nostalgia in the Afternoon," which appears here under the pseudonym "Incertus."

Happy Days, by Samuel Beckett, New York: Evergreen, 1961.

Robert W. Woodruff Library, Emory

Samuel Beckett to Alan Schneider,

autograph letter signed, 17 August 1961.

John J. Burns Library, Boston College

Sketches of the stage set of *Happy Days*, by Samuel Beckett, n.d.

John J. Burns Library, Boston College

Samuel Beckett's *Happy Days* premiered at the Cherry Lane theater in New York on September 17, 1961 and was first published as a softcover "Evergreen Original" the same year. The play was directed by Alan Schneider, and in the exchange of letters between the playwright and the director, Beckett outlines his thoughts on the staging of that original performance. The three accompanying sketches further elaborate Beckett's thoughts on the staging of this play, a play in which, as has been noted by critics, character and set are almost indistinguishable.

"All Over Again," by Louis MacNeice, manuscript draft, n.d. [ca. August 1959].

Harry Ransom Humanities Research Center, Texas

"In Carrowdore Churchyard," by Derek Mahon, *Outposts*, Summer 1965.

Collection of Ronald Schuchard

Louis MacNeice's love poem to Sylvia Shear "All Over Again" is composed of one "single torrential sentence," as biographer Jon Stallworthy describes it. The poem was collected in MacNeice's 1961 collection *Solstices*, published shortly before the poet's death in 1963.

Derek Mahon's verse tribute to MacNeice, "In Carrowdore Church-yard," was first published in the Summer 1965 issue of *Outposts*.

A rejected Heaney manuscript, Dolmen Press
ledger book, 1962.

Z. Smith Reynolds Library, Wake Forest

From 1962 onwards Liam Miller kept detailed records of all man-uscripts received by the Dolmen Press including, on this page, a manuscript titled "Advancements of Learning" submitted by Sea-mus Heaney in September 1964. Miller's notation indicates the manuscript was returned to Heaney with no further comment on March 2, 1965. Even as this manuscript was being rejected, how-ever, Heaney's poems were catching the eye of some appreciative and well-placed readers in London. That December Karl Miller selected three of Heaney's poems for publication in the *New Statesman*, and the following month Heaney received a letter from Charles Monteith, editor at Faber and Faber, asking to see more of his work. As Heaney has recalled, "I just couldn't believe it, it was like getting a letter from God the Father . . ."

The Belfast Group, group sheets for Seamus Heaney's
"Digging," Spring 1964, and Michael Longley's "No Continuing City," 1964.

Robert W. Woodruff Library, Emory

In 1963 Philip Hobsbaum, a recently-arrived lecturer in English at Queen's University, Belfast, organized a writing workshop made up of students, faculty, and a number of writers from the local community. The Group, as it has come to be known, met regularly during term at No. 4 Fitzwilliam Street, Philip and Hannah Hobsbaum's home near the university. Three years later, when Hobsbaum left Belfast for the University of Glasgow, Seamus

Heaney assumed responsibility for organizing the meetings, which moved to his and Marie Heaney's home on Ashley Avenue. Later Michael Allen and Arthur Terry, both lecturers at Queen's, played organizational roles as well. The Belfast Group lasted, with occasional interruptions, for nine years.

Many of the poems collected in Seamus Heaney's *Death of a Naturalist* were first read aloud in Group meetings, among them "Digging," "Personal Helicon," and "Blackberry-Picking." Similarly the Belfast Group provided a forum for early work by James Simmons, Michael Longley, Paul Muldoon, and Ciaran Carson. For each of these writers, the Group provided an early audience, for some their very first. As Seamus Heaney has put it, "What happened Monday night after Monday night in the Hobsbaum's flat in Fitzwilliam Street somehow ratified the activity of writing for all of us who shared it."

Philadelphia, Here I Come!, by Brian Friel,
London: Faber and Faber, 1965.

Robert W. Woodruff Library, Emory

As a young man, Brian Friel had little exposure to the theater in his native Co. Tyrone, and indeed he began his literary career as a short story writer. In the late 1950s he tried his hand at a series of radio plays, the most successful of which, *The Enemy Within*, had a run at Dublin's Abbey Theatre. Early in 1963 he was invited to spend three months at Tyrone Guthrie's theater in Minneapolis. Friel has written that "those months in America gave me a sense of liberation." After his return to Ireland, his first major play, *Philadelphia, Here I Come!*, was proclaimed the best Irish play of the year when it was first produced at the September 1964 Dublin Theatre Festival. The play traveled to London the following year before going on to Broadway in 1966.

Ten Poems, by Michael Longley, Queen's University of Belfast, Festival Publications, [October 1965].

Robert W. Woodruff Library, Emory

Eleven Poems, by Seamus Heaney, Queen's University of Belfast, Festival Publications, [November 1965]. Inscribed "For Edward Lucie Smith with gratitude and every good wish, Seamus Heaney 8 Nov. 1965."

Collection of James O'Halloran

Twelve Poems, by Derek Mahon, Queen's University of Belfast, Festival Publications, [December 1965].

Robert W. Woodruff Library, Emory

Queen's University began a publishing series in 1965 in conjunction with the annual Queen's Festival. The first three titles issued – Michael Longley's *Ten Poems*, Seamus Heaney's *Eleven Poems*, and Derek Mahon's *Twelve Poems* – were in each instance the very first book publication of these three poets.

Considerable bibliographic confusion has surrounded the date of publication of these three pamphlets, and one often encounters copies said to have been issued in later years. The purple nine-point sun motif that adorns each pamphlet was the design of the 1965 Festival. Reprints in the following year carry the ten-point sun motif in black or darker purple. The design was later dropped and subsequent issues appeared in heavy green wrappers with a design of a herald with drum and trumpet. The pamphlets were printed at the shop of the Botanic Printers near the campus.

As Harry Chambers noted in his review at the time, the appearance of the pamphlets left much to be desired. The sun motif was reminiscent of an advertisement for Wonderloaf (a popular but barely edible bread), while the printing generated "about as much typographical excitement as religious tracts." Nevertheless,

Ten poems

by

Michael Longley

FESTIVAL PUBLICATIONS
QUEEN'S UNIVERSITY OF BELFAST

Michael Longley's first collection, *Ten Poems,* was published in conjunction with the Queen's Festival in 1965.

he insisted, the publication of the first three pamphlets was an exciting event, a fact that could not be concealed even if the poems had been printed upside down.

In later years the Queen's Festival Publications series issued works by other leading Irish writers including Stewart Parker (*The Casuality's Meditation*), James Simmons (*Ten Poems*), Seamus Deane (*While Jewels Rot*), and John Montague (*Home Again*).

"CHECKMATE," telegram from Derek Mahon to Michael Longley, 8 July 1965.

Robert W. Woodruff Library, Emory

"The Less Deceived," Derek Mahon and Michael Longley, photograph, photographer not known, ca. 1965.

Robert W. Woodruff Library, Emory

Derek Mahon to Michael Longley, typed letter signed, n.d. [ca. December 1966].

Robert W. Woodruff Library, Emory

Derek Mahon and Michael Longley, classmates at Trinity College, Dublin, in the 1960s, enjoyed a particularly close creative friendship, and in 1965 the two poets shared the Eric Gregory Award for poetry. Mahon's telegram to Longley, after learning of the award, states simply "CHECKMATE" and conveys something of the friendly rivalry the two young poets shared. In the accompanying photograph taken around the same time, the two friends pose with a copy of Philip Larkin's *The Less Deceived*. In the accompanying letter, written from Toronto, one gets a clear sense of the collaborative relationship the two poets shared. "Go through the poems one by one, commenting as you go," Mahon writes to Longley. "If you think there's anything I should scrap, say so, with reasons."

35

Death of a Naturalist, by Seamus Heaney, London: Oxford University Press, 1966. Inscribed for Ron Schuchard with a quatrain titled "Waiting for the Gates":

> "Monet painted steam at the horizon
> And filled green space with a nineteenth century train.
> Paint me instead the fumes at Merrion,
> The windscreen steamed up and the barrier down."

Collection of Ronald Schuchard

"Digging," typescript, 1 page, August 26, 1964.

Loan of Seamus Heaney

"Personal Helicon," [variant title "An Apprenticeship"], holograph draft, 1 page, with three heavily corrected typescripts, 3 pages, n.d.

Loan of Seamus Heaney

["Death of a Naturalist"], by Seamus Heaney, holograph draft, n.d.

Loan of Seamus Heaney

Seamus Heaney's first major collection, *Death of a Naturalist* (preceded only by his Festival pamphlet), opens with "Digging," a poem that anticipates many of the mature poet's perennial themes even as it announces his own chosen vocation:

> "The cold smell of potato mould, the squelch and slap
> Of soggy peat, the curt cuts of an edge
> Through living roots awaken in my head.
> But I've no spade to follow men like them.
>
> Between my finger and my thumb
> The squat pen rests.
> I'll dig with it."

Among the other poems from that first collection which are displayed here in manuscript draft are "Death of a Naturalist" and "Personal Helicon," from which the title of this exhibition is drawn: "I rhyme / To see myself, to set the darkness echoing."

Eavan Boland to Michael Longley,

Autograph letter signed, 25 March 1966.

Robert W. Woodruff Library, Emory

New Territory, by Eavan Boland, Dublin: Allen Figgis,

1967. Signed.

Robert W. Woodruff Library, Emory

In this letter from the young Eavan Boland to Michael Longley, Boland reflects on Yeats's ability not to lose his understanding of beauty even in a time of violence. At the time, she was composing her own poem on this theme, "Yeats in Civil War," which would be published in her first collection of poems, *New Territory*, the following year. She closes that poem with this tribute to Yeats:

"Whatever we may learn
You are its sum, struggling to survive –
A fantasy of honey your reprieve."

[The Iron Island], by Paul Muldoon, autograph manuscript, ca. 1967.

> Robert W. Woodruff Library, Emory

Paul Muldoon as a young man, undated photograph.

> Robert W. Woodruff Library, Emory

"Stillborn" and "Sail," by Paul Muldoon, in *Threshold*, edited by Seamus Heaney, Summer 1969.

> Collection of Ronald Schuchard

> In the summer of 1967 Paul Muldoon went to live for a month with a local fisherman in Gweedore, Co. Donegal, where he practiced his Gaelic and read from a volume of Eliot's poetry that he had taken with him. During that summer, the sixteen-year-old Muldoon also composed *The Iron Island*, a poem sequence which he later abandoned and left unpublished. Among the first of his poems to appear in print were "Stillborn" and "Sail," which were selected by Seamus Heaney for a special number of the magazine *Threshold*. In the contributor's note to this issue, Heaney introduces the young Muldoon as a "Sixth former from Co. Tyrone," and adds, "These are his first poems to be published."

Broadsheet, edited by Hayden Murphy, No. 4, featuring "Last Lines," by Seamus Heaney, and "Homecoming," by Derek Mahon, [May 1968].

> Robert W. Woodruff Library, Emory

> Between 1967 and 1978 the poet Hayden Murphy published a series of inexpensive broadsides, titled simply *Broadsheet*, which he sold in pubs and other locations in and around Dublin. Due to their ephemeral nature, most copies have not survived. In this copy, Seamus Heaney's "Last Lines" appears alongside Derek Mahon's "Homecoming."

Derek Mahon with his parents, two photographs, Glengormley, September 1960.

Robert W. Woodruff Library, Emory

Night-Crossing, by Derek Mahon, London: Oxford University Press, 1968. Inscribed "For Mum & Dad with love — Derek."

Robert W. Woodruff Library, Emory

Derek Mahon's first major collection, *Night-Crossing*, was preceded by his Festival pamphlet, *Twelve Poems*, in 1965 and by the chapbook *Design for a Grecian Urn*, which was published in Cambridge, Massachusetts, in 1966. This, his first full-length collection, was published by Oxford University Press in 1968. A number of the poems collected in this first volume – "In Belfast," "Glengormley" – express in some measure the poet's own ambivalence toward the post-war housing estate where his parents moved when he was a student. "One part of my mind must learn to know its place – " he writes in "In Belfast." This copy of *Night-Crossing* is inscribed to the poet's parents, "For Mum & Dad with love."

Door Into the Dark, by Seamus Heaney, London: Faber and Faber, 1969. Inscribed by Seamus Heaney to Derek Mahon: "To Derek, who has seen perhaps 10,000 books like this etc. 21 June 1969."

Collection of James O'Halloran

"Bogland," by Seamus Heaney, typescript with holograph revisions, 2 pages, n.d.

Loan of Seamus Heaney

Seamus Heaney composed "Bogland" after visiting Donegal with the painter T. P. Flanagan in 1968. While Flanagan made sketches of the landscape, Heaney registered his own impressions. As

Heaney recalled, neither shared his reaction with the other; instead there was "an unvoiced decision not to discuss the landscape," but for each to "preserve his isolation." Heaney's discovery of the bog as subject led to a rich exploration of its metaphorical possibilities in numerous later poems.

The Táin, translated by Thomas Kinsella, with brush drawings by Louis le Brocquy, Dublin: Dolmen Press, 1969. No. 22 of 50 deluxe copies, signed by Kinsella, le Brocquy, and Miller

Robert W. Woodruff Library, Emory

The Táin bó Cuailnge from the Yellow Book of Lecan, edited by John Strachan and J.G. O'Keeffe, Dublin: School of Irish Learning, 1912, with extensive revisions and working notes in Kinsella's hand.

Robert W. Woodruff Library, Emory

Stories from the Táin, edited by John Strachan, Dublin: Royal Irish Academy, 1944, with extensive notes in Kinsella's hand.

Robert W. Woodruff Library, Emory

"Thomas Kinsella reads from his new translation of the epic Táin Bó Cuailnge," broadside for Peacock Theatre reading, n.d.

Robert W. Woodruff Library, Emory

The Dolmen Press edition of the Irish epic *The Táin* has been described as the high point of the press's achievement for the quality and care of its bookmaking. It was also, however, an important act of cultural reclamation of an ancient text that Kinsella has described as "the nearest approach to a great epic that Ireland has produced."

Thomas Kinsella began the translation in 1963. At the time as

he has recalled, "there were plenty of 'retellings' in the bookshops, but actual translations were scarce, and those I could find were generally dull. . . . It seemed extraordinary that, for all the romanticised, fairy tale, versified, dramatised and bowdlerised versions of the Ulster cycle, there had never been a readable translation of the older version of the *Táin*, tidied a little and completed from other sources – nothing in English to give an idea of the story as we have it. So I undertook the present translation, and completed it as time offered."

Among Kinsella's many source texts, which are held at the Robert W. Woodruff Library, are John Strachan and J.G. O'Keeffe's *The Táin bó Cuailnge from the Yellow Book of Lecan* and John Strachan's *Stories from the Táin*.

"If you want to read – sign," sign-up book for a Tara Telephone poetry session, n.d.

Robert W. Woodruff Library, Emory

Tara Telephone Publications, account book, 1969.

Robert W. Woodruff Library, Emory

Brendan Kennelly and Peter Fallon, photograph, early 1970s.

Robert W. Woodruff Library, Emory

Answers: A Selection of Poems, by Des O'Mahony and Justin McCarthy, Dublin: Tara Telephone Publications, February 6, 1970. No. 9 of 50 numbered and signed copies.

Collection of James O'Halloran

In 1969 Peter Fallon organized a series of poetry workshops that convened fortnightly in a rented room at 51 Parnell Square in Dublin. "If you want to read – sign," this workshop notebook

instructed participants. "From the reading series," Fallon has written, "grew my sense, first, that some of these poems merited publication, and second, that there weren't many magazines or other outlets particularly receptive to the work of the new and the young. . . ." Peter Fallon and Eamon Carr issued their first book, *Answers*, by Des O'Mahony and Justin McCarthy, under the unlikely imprint of Tara Telephone in February 1970. The name was soon changed to The Gallery Press, widely regarded today as Ireland's leading literary publisher.

Recalling this beginning to his publishing activities, Fallon has written, "It began in innocence and ignorance . . . two regular participants in the open reading series may not appear the most auspicious of beginnings (consider Dun Emer's / Cuala's in comparison!), but it belonged in and was true to the time. I was then still a student at Trinity College, Dublin, and when I sold enough copies of that book I paid the printers and prepared another."

Early diaries of Medbh McGuckian, 1969-1971.

Robert W. Woodruff Library, Emory

"The Idea of an Anglo-Irish Poetic Tradition," by Medbh McGuckian, holograph essay written for McGuckian's instructor "Mr. Heaney" with notes in Seamus Heaney's hand, [ca. 1971].

Robert W. Woodruff Library, Emory

Medbh McGuckian, photograph by John Minihan, London, 1996.

Robert W. Woodruff Library, Emory

In these diaries, dating from the years when Medbh McGuckian was studying Irish literature under Seamus Heaney at Queen's University, Belfast, the young McGuckian records her daily activ-

ities, comments on her progress in school, and notes as well the escalation of violence in Belfast at the time. In the accompanying essay, "The Idea of an Anglo-Irish Poetic Tradition," written for Seamus Heaney, McGuckian draws parallels between "the present political and social crisis" and that faced by Yeats in his own time. In his comments on the essay, Seamus Heaney praises the young McGuckian for her "firmly outlined and passionately engaged" essay. "One of the best things I've read on the subject."

Knowing My Place, by Paul Muldoon, mock-up of first poetry pamphlet, 1971.

Robert W. Woodruff Library, Emory

Knowing My Place, by Paul Muldoon, Belfast: Ulsterman Publications, 1971.

Collection of Ronald Schuchard

Paul Muldoon's first collection, the chapbook titled *Knowing My Place*, was published by Ulsterman Publications after Muldoon had entered Queen's University, Belfast, where he studied under Seamus Heaney. In his letter accompanying the poems, Muldoon wrote to poet and publisher Frank Ormsby, "I'm sending along one [manuscript] called 'Knowing My Place' – it's so po-faced that even I can see it. But yez might consider publishing it, if you would."

Butcher's Dozen, by Thomas Kinsella, Dublin: Peppercanister, 1972.

Robert W. Woodruff Library, Emory

Butcher's Dozen, by Thomas Kinsella, Dublin: Peppercanister, 1972. No. 12 out of a special edition of 125 signed copies.

Robert W. Woodruff Library, Emory

KNOWING
MY
PLACE

by
PAUL
MULDOON

Price :
TEN NEW PENCE

Paul Muldoon's first poetry collection.

Butcher's Dozen, the first title published under Thomas Kinsella's Peppercanister imprint, was published hurriedly on April 26, 1972, just one week after the report of the Widgery Tribunal of Inquiry into the shooting of thirteen civil rights demonstrators by British troops in Derry on January 30, 1972. As Kinsella has recalled, "the poem was finished quickly and issued as a simple pamphlet at ten pence a copy; cheapness and coarseness were part of the effect, as with a ballad sheet." Kinsella first considered publishing the work anonymously or under the name Peppercanister (the popular name of St. Stephen's Church on Upper Mount Street, Dublin); however, he decided in the end to publish it under his name, and from that point forward Peppercanister became a personal imprint that allowed him greater control over the appearance of his later work.

Catholics, by Brian Moore, Toronto: McClelland and Stewart, 1972. Advance proof copy, signed.

Collection of James O'Halloran

Brian Moore began writing *Catholics* in the summer of 1971, but he confided in a letter to his friend the playwright Brian Friel that he had doubts whether the novel would ever be published. In fact, this story of divisions within the Catholic Church was published, first by McClelland and Stewart in Canada, and also made into a popular television film which further broadened Moore's audience in America. The novella received the W. H. Smith Award when it was issued in Britain, while the television adaptation – directed by Jack Gold – received a Peabody Award the following year. The novelist Graham Greene said of it, "I think it is probably the best book of a writer whom I very much admire."

The Rough Field, by John Montague, Dublin: Dolmen

Press, November 1972. No. 27 of 150 copies specially bound copies featuring hand-colored illustrations.

Collection of James O'Halloran

The Rough Field, by John Montague, Winston-Salem:

Wake Forest University Press, 1989. Inscribed to Ron Schuchard: "For Ron who eggs me on to fresh devilment."

Collection of Ronald Schuchard

"Like dolmens round my childhood . . ."

manuscript draft of "Home Again," corrected typescript, n.d.

SUNY Buffalo

"An Ulster Epic: The Rough Field," by John

Montague, promotional circular for reading bySeamus Heaney, Benedict Kiely, Tom McGurk, Patrick Magee, John Montague, July 8th, [1973].

Loan of John Montague

In an unpublished prose memoir, the Belfast-born poet Derek Mahon recalls entering the May Morton Poetry Prize contest in 1960: "My entry was one of the Dylan Thomas pastiches I was attempting at the time, but it seemed to me that the outcome was a foregone conclusion: I would win; not because my poem was any good but because there would be nobody else competing. No young person in Belfast, or Northern Ireland for that matter, wrote poetry except me, so far as I was aware; indeed, I assumed that nobody except me wrote poetry at all, really: all that belonged to the past, or at least to the illustrious ancients who were either dead or over 50. (Besides, nobody else would have noticed the advertisement.) Imagine my puzzlement, therefore, when the winner was announced and proved to be someone called John Montague, whose entry was entitled, oddly, 'Like Dolmens Round My Childhood, the Old People,' a poem which has since become justly famous."

46

John Montague's poem, which has indeed become "justly famous," was later collected and published in book form in *The Rough Field*.

New Weather, by Paul Muldoon, revised printer's proof, 1972.

Robert W. Woodruff Library, Emory

Paul Muldoon to Frank Ormsby, autograph letter signed, July 25 [1972].

Robert W. Woodruff Library, Emory

In addition to periodicals and his early chapbook, *Knowing My Place*, a selection of Paul Muldoon's poems had also been published in *Poetry Introduction 2* in 1972. That selection was followed quickly by the publication of *New Weather* under the Faber and Faber imprint. That same year Muldoon received the Eric Gregory Award for poetry. In this unassuming letter to his friend Frank Ormsby, Muldoon writes, "I suppose you heard about the Faber thing; I sent some [poems] along to them and I hope you will too."

Seamus Heaney, Portrait head by Lyn Kramer, bronze, 1978.

Collection of James O'Halloran

North, by Seamus Heaney, London: Faber and Faber, 1975.

Inscribed "We men of the north had a word to say / And we said it then in our own dour way / And spoke as we thought best . . ." (a quote from Florence M. Wilson's "The Man from God Knows Where").

Collection of Ronald Schuchard

"North" [variant titles "North Atlantic" and "Northerners"], by Seamus Heaney, holograph draft, 2 pages, n.d.; with three corrected typescripts, n.d.

Loan of Seamus Heaney

This series of manuscript drafts – revealing variant titles "North Atlantic," "Northerners," and "North" – documents the develop-

ment of this, the title poem, of Heaney's major collection *North* published in 1975.

Lig Sinn i gCathú, by Breandán Ó hEithir, Baile Átha Cliath, Sáirséal agus Dill, 1976. Inscribed.

Collection of James O'Halloran

Breandán Ó hEithir was a noted Irish-language journalist, broadcaster, and novelist who also wrote in English. His first novel *Lig Sinn i gCathú* published on St. Patrick's Day 1976 became an immediate best seller – the first such book in the Irish language to do so.

Proxopera, by Benedict Kiely, final manuscript draft from which the typescript was made.

Collection of James O'Halloran

Proxopera, by Benedict Kiely, London: Victor Gollancz, 1977. Inscribed.

Collection of James O'Halloran

Benedict Kiely is the dean of Irish literary figures. Novelist, short story writer, lecturer, journalist and gifted raconteur, he has been a major presence in Irish letters since the publication of his first book in 1945. The short novel *Proxopera* is one of his more powerful books. Set in the north of Ireland, it tells the story of a farmer forced by masked men, who are holding his family hostage at gunpoint, to drive a bomb, concealed in a milk churn, into his local town. Brian Moore used the same basic theme for his 1990 novel *Lies of Silence*.

Benedict Kiely, two phtographs by Kathryn Cahill, n.d.

Collection of Christopher Cahill

Toome, by Seamus Heaney, Dublin: National College of Art & Design, 1980. No. 6 of 15 copies.

Collection of James O'Halloran

This little-known collection of Seamus Heaney's poems was conceived and illustrated by Jane Proctor for an art project at the National College of Art and Design in 1980. The poems, a number of which had previously appeared in Heaney's 1973 collection *Wintering Out*, were printed letterpress and accompanied by nine silkscreen prints.

"Field Day presents *Translations* by Brian Friel," theater program for opening performance, n.d.

Robert W. Woodruff Library, Emory

Field Day Pamphlets: A New Look at the Language Question, by Tom Paulin; *An Open Letter*, by Seamus Heaney; *Civilians and Barbarians*, by Seamus Deane, Derry: Field Day Theatre Company, 1983.

Robert W. Woodruff Library, Emory

Brian Friel to Tom Paulin, autograph letter, signed, 29 October [1982]; with "An invitation from Field Day Theatre Company," n.d.

Robert W. Woodruff Library, Emory

Directors of the Field Day Theatre Company, photograph: Brian Friel, Tom Paulin, Seamus Deane, David Hammond, Seamus Heaney, and Stephen Rea, ca. 1983.

Robert W. Woodruff Library, Emory

In this letter to Tom Paulin, Brian Friel reveals something of the nature of the internal conversation that took place among the Field Day directors over the purposes and aims of their fledgling theater company:

"I know that the core of Field Day is theatrical. But because its voice is Northern, its direction Northern, its base and focus Northern, and not least because of the state of the North now … I am all for Field Day finding means of expression as well as theatrical; so that the theatrical and the 'literary' would nurture and complement one another. Aren't we really talking about the creation of a taste by which we will be assessed? That can be accomplished by using more than one voice."

As part of that aim, the Company issued a series of pamphlets, the first three of which are displayed here, that amplified the group's message beyond the theater. According to minutes kept of the Field Day meetings, Seamus Heaney argued for a simple cardboard cover, which the other directors agreed on. The paper, however, was to be high quality, as the anonymous recorder of the meeting noted, "acknowledging the possibility of ephemerality but remaining convinced of the gratitude of posterity."

Fivemiletown, by Tom Paulin, London: Faber and Faber, 12 October 1987.

Collection of James O'Halloran

Fivemiletown, by Tom Paulin, notebook containing draft contents page for projected collection, n.d.

Robert W. Woodruff Library, Emory

In addition to being an influential critic of Ireland's political culture, Tom Paulin is also the author of seven collections of poems: *A State of Justice*, *The Strange Museum*, *The Book of Juniper*, *Liberty Tree*, *Fivemiletown*, *Walking a Line*, and *The Wind Dog*. In this

manuscript notebook the poet Paulin has drafted a planned arrangement for his 1987 collection *Fivemiletown* reflecting numerous poems which were omitted or published in the volume in a different order. The accompanying manuscript notebook shows Paulin's manner of composing in long-hand.

Stirrings Still, by Samuel Beckett, Blue Moon Books, 1988.
Limited ed. of 226 copies, signed by the author and artist.

Collection of Kevin M. Cahill, M.D.

This, the last work published by Samuel Beckett during his life-time, was published by Beckett's long-time friend and publisher Barney Rosset under his Blue Moon Books imprint in 1988. The collection of spare verse was illustrated with a single lithographic image of Beckett by Louis le Brocquy and eight additional lithographic drawings. The volume was quarter bound in parchment with a natural linen and cotton cloth stamped with a motif by the artist in eighteen carat gold and supplied with a matching slipcase.

Samuel Beckett, watercolor by Louis le Brocquy, [ca. 1980s].
Collection of Kevin M. Cahill, M.D.

On Ballycastle Beach, by Medbh McGuckian,
Winston-Salem: Wake Forest University Press, 1988.

Collection of Ronald Schuchard

"On Ballycastle Beach," by Medbh McGuckian,
holograph draft, n.d.

Robert W. Woodruff Library, Emory

Medbh McGuckian submitted her poem "The Flitting" under a male pseudonym and won, under that name, the National Poetry

Competition in 1979. Her first two collections, *The Flower Master* and *Venus and the Rain*, were followed by *On Ballycastle Beach*, a collection that explores an intense inner life and in so doing traces boundaries of body, home, and family.

A Kind of Scar: The Woman Poet in a National Tradition, by Eavan Boland, Dublin: Attic Press, 1989. Signed.

Collection of Ronald Schuchard

In this important reappraisal of Irish women's contributions to Irish literature, poet Eavan Boland writes: "Over a relatively short time – certainly no more than a generation or so – women have moved from being the subjects and objects of Irish poems to being the authors of them. It is a momentous transit. It is also a disruptive one."

Amongst Women, by John McGahern, London: Faber and Faber, 1990.

Collection of James O'Halloran

From the start – his first novel, *The Barracks*, was published in 1963 and his second, *The Dark*, in 1965, was banned in Ireland and cost him his job as a schoolteacher in Dublin – John McGahern's work has been consistently acclaimed. The publication in 1990 of *Amongst Women*, his fifth novel, was a breakthrough of sorts: it was short-listed for the Booker Prize, won both the GPA and the Irish Times awards and was made into a four-part BBC television series. This story of a rural family ruled by a strong-willed father brought McGahern, who is often referred to as the Irish Chekov, a far wider readership than he previously enjoyed. He has recently published, again to great critical acclaim, his sixth novel, *That They May Face the Rising Sun* (US title *By the Lake*), set in rural

Ireland with its almost vanished culture of independence and individuality.

Nuala Ní Dhomhnaill, portrait head by Fleur
Fitzgerald, bronze, 1999.

Loan of Fleur Fitzgerald

"Éirigh, A Éinín," by Nuala Ní Dhomhnaill, typescript
with holograph corrections; with English translation, "Celebration,"
by Michael Hartnett, holograph draft, n.d.

John J. Burns Library, Boston

Nuala Ní Dhomhnaill, Ireland's leading Irish language poet, was
born and raised in the Irish-speaking areas of West Kerry and
Tipperary. *Pharaoh's Daughter*, published by the Gallery Press in
1990, included forty-five of her poems in Irish with translations by
many of the country's leading English language poets, including
Ciaran Carson, Michael Coady, Peter Fallon, Michael Hartnett,
Seamus Heaney, Michael Longley, Medbh McGuckian, Tom
MacIntyre, Derek Mahon, John Montague, Paul Muldoon,
Eiléan Ní Chuilleanáin, and George O'Brien.

Gorse Fires, by Michael Longley, Winston-Salem: Wake
Forest University Press, 1991.

Robert W. Woodruff Library, Emory

"Detour," by Michael Longley, corrected typescript, n.d.

Robert W. Woodruff Library, Emory

With the publication of *Gorse Fires* in 1991, Michael Longley
broke a twelve-year silence. The collection, which included the
poem "Detour," on display here in manuscript, was greeted with
critical praise and won the Whitbread Poetry Prize.

Paddy Clarke, Ha Ha Ha, by Roddy Doyle,
London : Secker & Warburg, 1993.

> Collection of James O'Halloran

> "It's not my life, but it's my geography," Roddy Doyle has said of his 1993 novel, *Paddy Clarke, Ha Ha Ha.* The novel, Doyle's fourth, is told entirely from the point of view and in the words of ten-year-old Paddy Clarke. The novel received the prestigious Booker Prize in 1993.

Paul Muldoon

> Portrait head by Fleur Fitzgerald, bronze resin, 2001.
> Loan of Fleur Fitzgerald

Incantata, by Paul Muldoon, Dublin: Graphic Studio Dublin,
1994. No. 6 of 50 numbered copies for sale, out of a total edition of 75 copies.

> Robert W. Woodruff Library, Emory

"Incantata V," by Paul Muldoon, potato print, n.d.

> Robert W. Woodruff Library, Emory

> Paul Muldoon's 1994 elegy "Incantata" was dedicated to the artist Mary Farl Powers, with whom Muldoon had once made a series of potato prints. The long poem published after her death by the Graphic Studio Dublin opens with a recollection of those potato prints:

> "I thought of you tonight, a leanbh, lying there in your long barrow colder and dumber than a fish by Francesco de Herrera, as I X-actoed from a spud the Inca glyph for a mouth: ..."

> "Incantata" was collected the same year in Paul Muldoon's *The Annals of Chile*, the dustjacket of which also incorporated this same potato print design.

DETOUR

~~TODETOUR~~

 funeral Then
I want my ~~last journey~~ to include a detour
Down the single street of a small country town,
On either side of the procession such names ~~as~~
 Darragh O'Malley;
As ~~Darragh,~~ Kenny, MacNamara, ~~Philbin,~~ Keane.
A reverend pause to let a herd of milkers pass
 muddy
Will bring me face to face with parsnips, carrots
 shower is rinsing
A ~~light rain~~ is rinsing ~~green~~ on the pavement,
Then
~~Hoes,~~ hay rakes, broom handles, and gas cylinders.
 the
Reflected in a slow sequence of shop windows
I shall ~~miss~~ part of the action when his wife
Draining the potatoes into a steamy sink
 kitchen
Calls to the grocer to get ready for dinner
~~Then~~ the publican descends to change a barrel.
 locked
From behind the one ~~closed~~ door for miles around
 picking a detailed
I shall ~~hold a confidential~~ conversation
With the man in the concrete telephone kiosk
About ~~yesterday's crumpled starting prices~~
Or the riddle on ~~a~~ discarded ice-lolly stick.

About where my funeral will be going next.
 night

Hanging above the pavement in a rainstorm
And carrots hanging out in a rainstorm
As Philbin, O'Malley, MacNamara, Keane

"Detour," by Michael Longley.

"The 12th Street Letter," by Derek Mahon, corrected typescript, [ca. 1992].

Robert W. Woodruff Library, Emory

Derek Mahon broke a lengthy silence with the publication of his long poem sequence, *The Hudson Letter,* in 1995. The published poem puts forward the fiction that the poem was composed in a nine month period from January to September 1995. That particular span of time is significant since Mahon's move from New York to Dublin in June of that year offers a resolution to one of the major crises of the poem, that is, the poet's displacement from home and country. Manuscript evidence, however, including the original title struck through on this early draft, suggests the poem was actually begun in 1992 when Mahon was living in an apartment on West 12th Street.

1995 Nobel Prize for Literature, medallion

Loan of Seamus Heaney

"Crediting Poetry," photocopied typescript with corrections in the hand of Peter Fallon, [December 1995].

Robert W. Woodruff Library, Emory

"The Strand," by Seamus Heaney, with watercolor by Felim Egan, Loughcrew: Gallery Press, 1995.

Robert W. Woodruff Library, Emory

The Nobel Committee announced Seamus Heaney was the winner of the 1995 Nobel Prize for Literature on October 5, 1995, while Heaney was traveling in Greece. The Committee, in its announcement, cited his "works of lyrical beauty and ethical depth, which exalt everyday miracles and the living past." Heaney's Nobel lecture, titled *Crediting Poetry*, was hurried into print in

56

time for the December award ceremony. Changes were relayed to Peter Fallon, Heaney's friend and publisher, by fax and by telephone and hurriedly corrected as in this marked text. Heaney's 1995 Christmas greeting, titled "The Strand," followed soon after: "The dotted line my father's ashplant made / On Sandymount Strand / Is something else the tide won't wash away."

The Steward of Christendom, by Sebastian Barry, spiral bound corrected typescript, n.d.

Harry Ransom Humanites Research Center, Texas

Raised in a theatrical family, Sebastian Barry published poems, stories, novels, and plays before his 1995 history play *The Steward of Christendom* opened to critical praise at London's Royal Court Theatre. The play tells the story of an aging Irish Catholic loyalist who must reconcile himself to Ireland's recent history and his own place in it. This Lear-like drama, based on Barry's own great-grandfather, was a major theatrical achievement for the young playwright.

Angela's Ashes, Frank McCourt, New York: Scribner, 1996. Advance Reader's Copy/Uncorrected Proof. Signed.

Collection of James O'Halloran

Angela's Ashes, Frank McCourt's sad, harrowing, humorous, irrepressible memoir of life in the slums of Limerick in the 1940s burst on the publishing scene in 1996. It went straight to the best seller list where it stayed for the rest of the decade. The same happened upon its publication in Europe. It is undoubtedly one of the most widely read books of the 1990s.

Reading in the Dark, by Seamus Deane, London: Jonathan Cape, 1996.

Reading in the Dark, manuscript draft, n.d.

Loan of Seamus Deane

The critic Seamus Deane was born in Derry and attended St. Columb's College where he was a classmate of Seamus Heaney. In his distinguished academic career, Deane has written widely on Irish history and culture. His first novel, *Reading in the Dark*, tells the story of a young boy who must confront his own family history in a violence-torn Ireland. The autobiographical novel was shortlisted for the Booker Prize in 1996.

Derek Mahon

Portrait head by Fleur Fitzgerald, bronze resin, 2000.
Loan of Fleur Fitzgerald

The Yellow Book, by Derek Mahon, Loughcrew: Gallery Books, 1997. Author's working copy with extensive revisions.

This working copy of Derek Mahon's 1997 poem sequence *The Yellow Book* contains numerous autograph revisions to the text made after the book's publication. Many of these changes were later reflected in Mahon's *Collected Poems,* which was published by Gallery in 1999. *The Yellow Book* is open here to section XVI, "America Deserta," which recalls the poet's own New York years in the early nineties:

"I think of diner mornings in ice and thaw,
the Lion's Head, renamed the Monkey's Paw,
and moments on the Hudson River Line;

you wildly decadent in forbidden furs
in the shadow of the Bobst or the Twin Towers,
the skyline at your back, the pearl rope bridges
and a nation singing its heart out in the business pages."

The Weather in Japan, by Michael Longley, London:
Jonathan Cape, 2000.

Robert W. Woodruff Library, Emory

Michael Longley quickly followed the breakthrough collection
Gorse Fires with *The Ghost Orchid* in 1995 and *The Weather in Japan*
in 2000. The latter, a collection of poems of lyric power, received
the Hawthornden Prize and the T. S. Eliot Prize, before Longley
was awarded the Queen's Gold Medal for Poetry early in 2001.

XVI

America Deserta

*High in the air float green-blue copper roofs
like the tips of castles rising from the clouds
in fairy tales and cigarette advertisements.*

*— Zelda Fitzgerald,
Harper's Bazaar, 1929*

Often enough you've listened to me complain
of the routine sunlight and infrequent rain
beyond the ocean blue; and now, beyond,
where once it never drizzled but it poured,
in dirty Dublin and even in grim Belfast
our cherished rainfall is a thing of the past,
our climate now that of the world at large
in the post-Cold War, global-warming age
of corporate rule, McPeace and Mickey Mao.
Imitative in all things, we mimic now,
as nature art, the general new-age weather,
a smiley-face of glib promotional blather;
anxious not to be left behind, we seize
on the dumb theory and the prescribed disease
who were known once for witty independence
and valued things beyond the world of sense;
subscribing eagerly to the post-modern kitsch
we shirk our noble birthright as the glitch
in the internet, the thorn in the side, the pain
in the neck and the (holy) ghost in the machine.
An alien among aliens during my New York time
spying for the old world in the new, thought-crime
grown secretly like a window-box of cannabis
in the shocking privacy of a book-lined space,

I valued above all our restful evening walks
to the West Side pierheads and the desolate docks
under a sunset close-encounter blaze
to watch the future form from the heat-haze
in the garbage-mouth of the Hudson. We never hung
those retro scenes beloved of Sam Menashe
and the hard-drinking, chain-smoking Eurotrash —
an older America of the abrasive spirit,

Back home, I surf the bright box for world news
and watch with sanctimonious European eyes
the continuing slave narrative, people in chains,
the limp ship firing into the vegetation,
stick children, tanks, where once again warplanes
emerge from rain-clouds with a purposeful growl
as in the depths of Nostradamus' midnight water-bowl;
drought, famine, genocide, frustrated revolution
and the silent roar of 'ant-like' migration,
all this to serve discredited ambition
and the pages of *Vanity Fair* and *Harper's Bazaar*.
Not long from barbarism to decadence, not far
from liberal republic to defiant empire
and thence to entropy; not long before
the pharaonic scam begins its long decline

46

List of Lenders

John J. Burns Library, Boston College

State University of New York, Buffalo

Christopher Cahill

Kevin M. Cahill, M.D.

University of Calgary Library

Seamus Deane

J. P. Donleavy

Fleur Fitzgerald

Seamus Heaney

Eamon Mallie

John Montague

James O'Halloran

Harry Ransom Humanities Research Center,
 University of Texas at Austin

Ronald Schuchard

Z. Smith Reynolds Library, Wake Forest University

Robert W. Woodruff Library, Emory University

500 COPIES PRINTED FROM CASLON TYPES
ON COUGAR OPAQUE PAPER. DESIGN AND
TYPOGRAPHY BY JERRY KELLY.